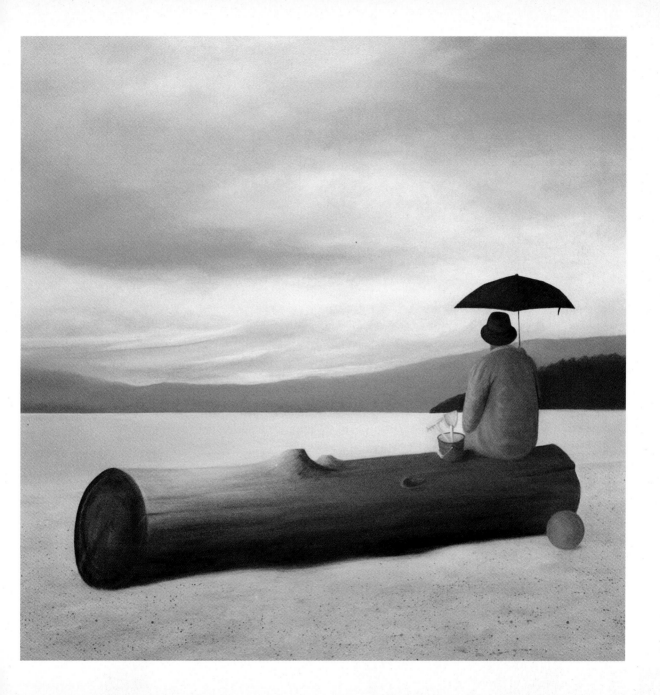

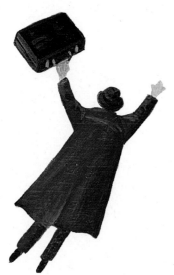

Dedicated to Mr. M.

"If the dream is a translation of waking life,
waking life is also a translation of the dream."
– René Magritte

Mr. M

The Exploring Dreamer

Soizick Meister

Words by K. George

READ LEAF

Mr. M's introspection takes flight.

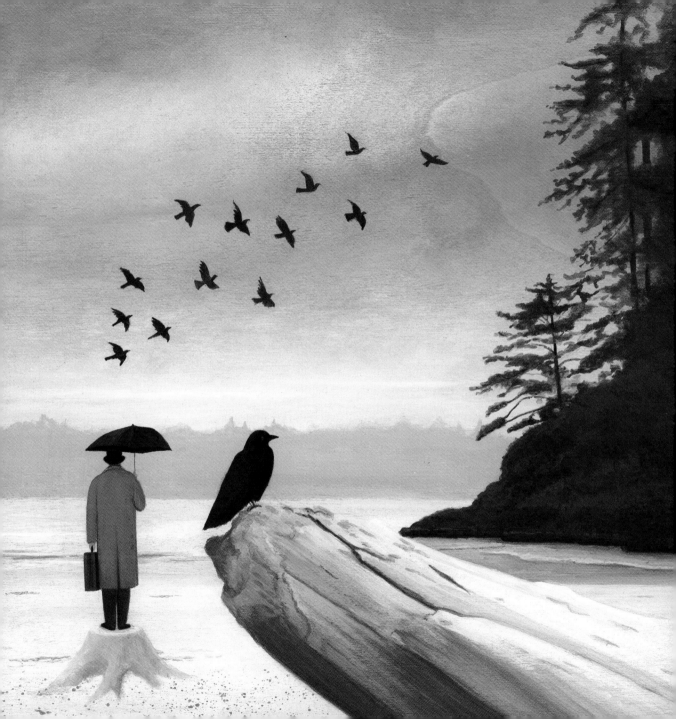

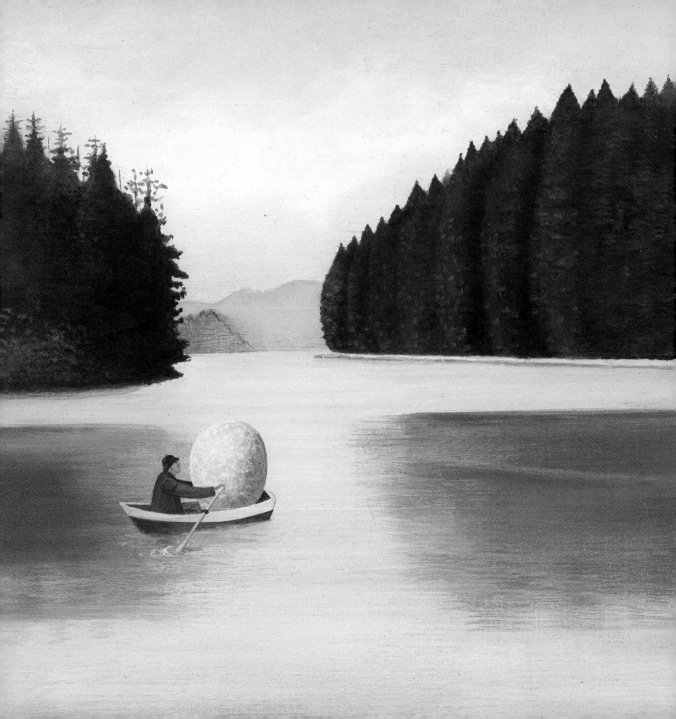

With a Sisyphean encumbrance, he ferries forth.

His panoply of thoughts precipitates melancholy.

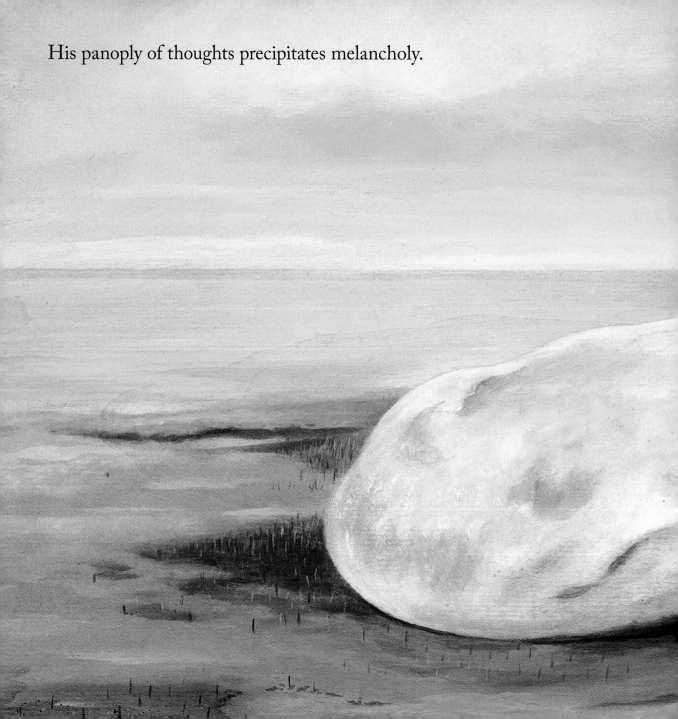

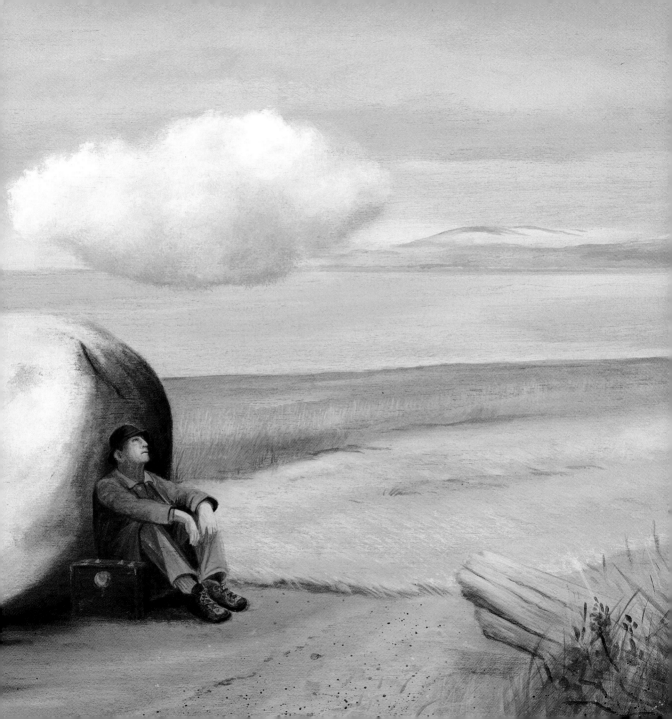

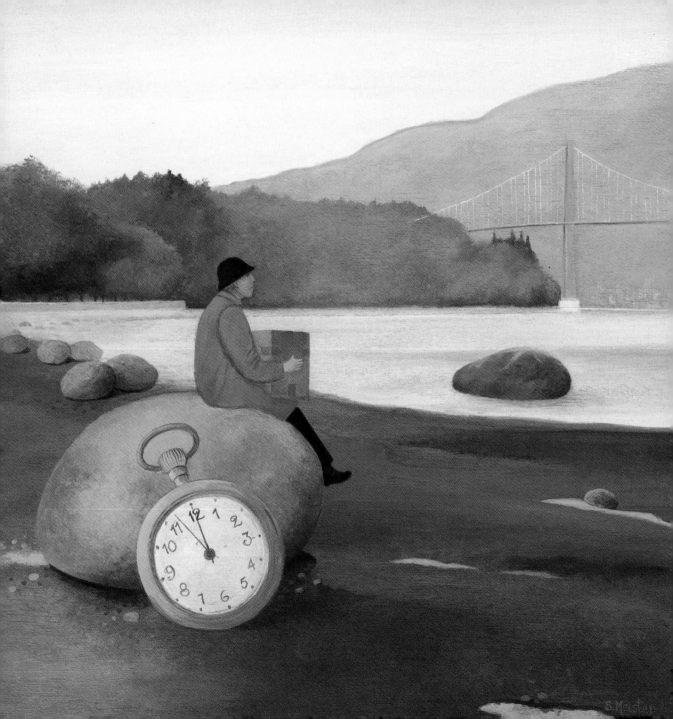

As he deliberates, time packages life, consigning it to antiquity.

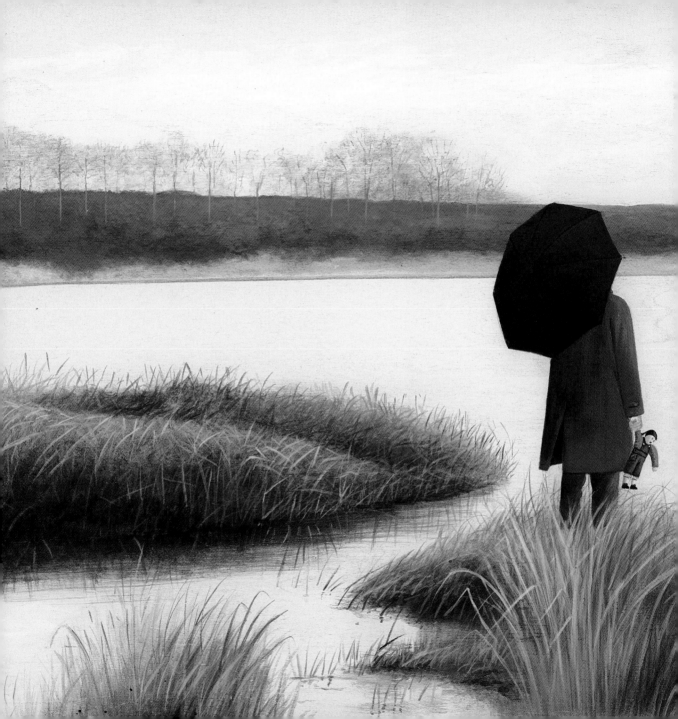

Standing in redolent grass, he toys with his memories.

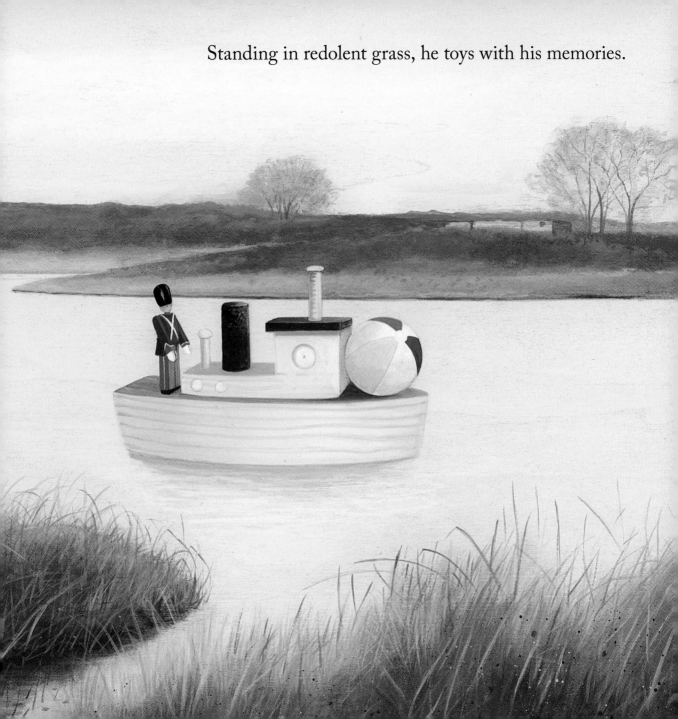

His reveries fold the past into the future.

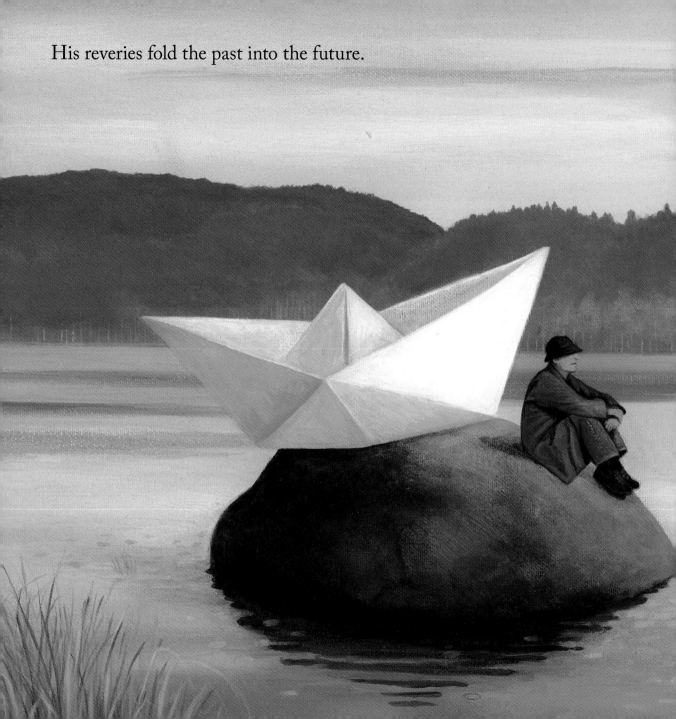

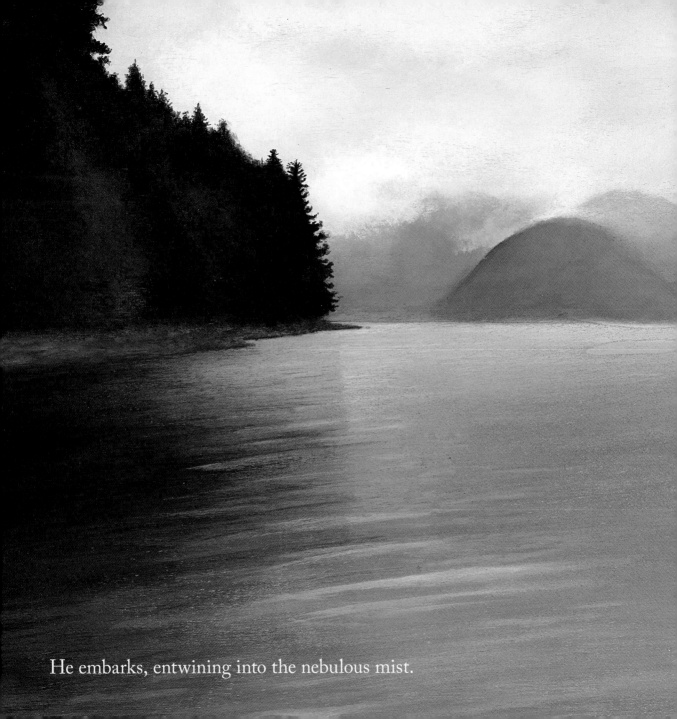

He embarks, entwining into the nebulous mist.

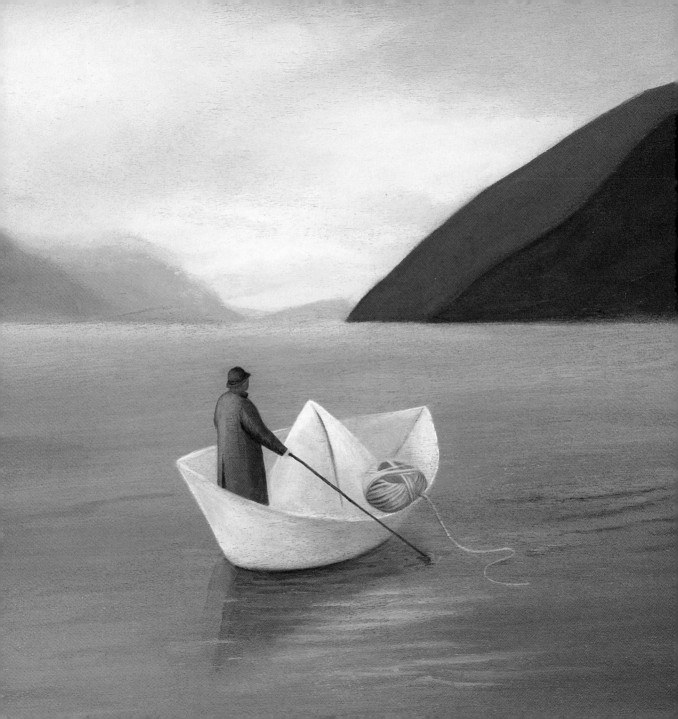

The past stalks surreptitiously in his footsteps.

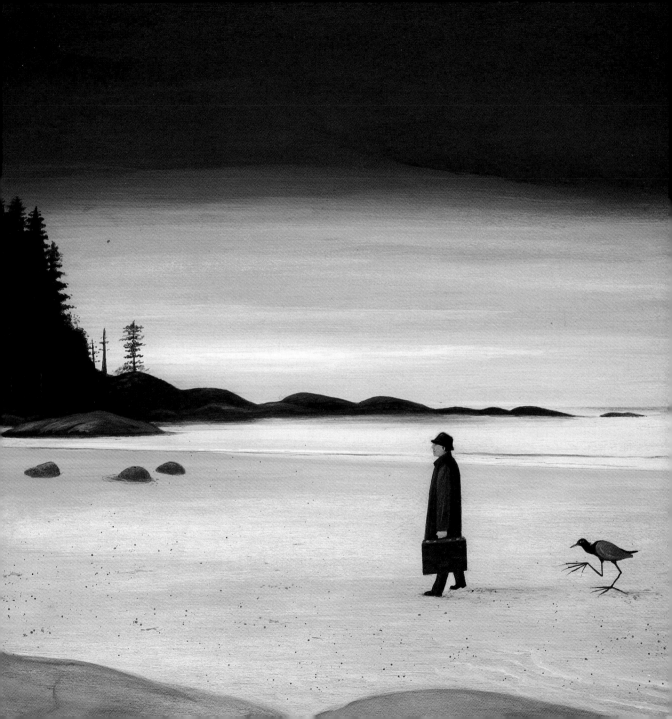

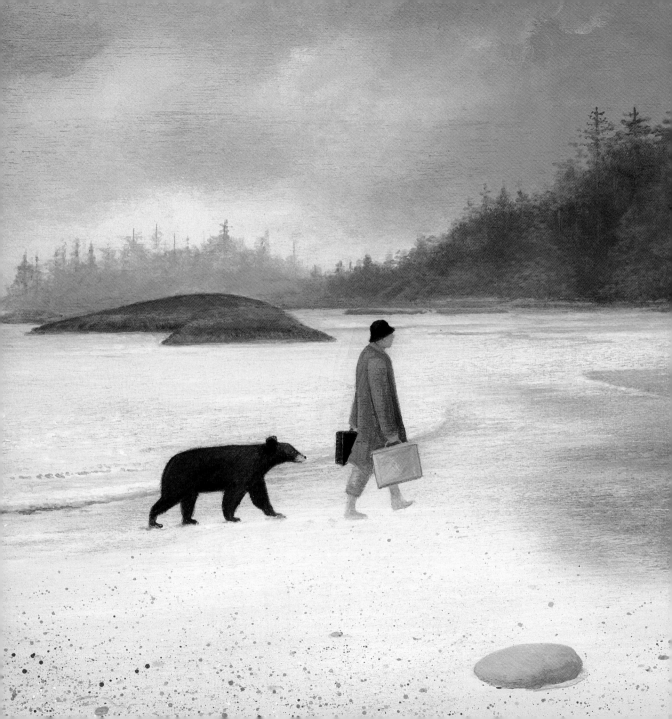

Barefoot, the two sojourn in solitude.

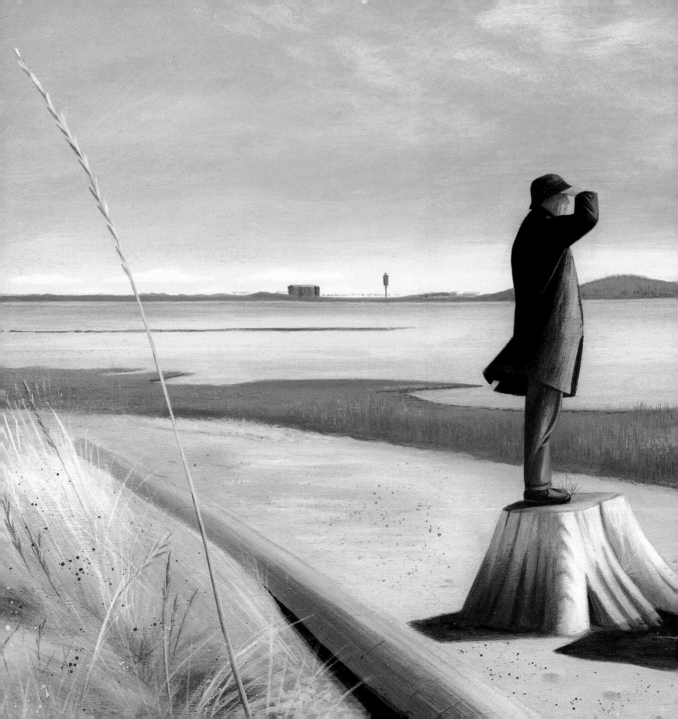

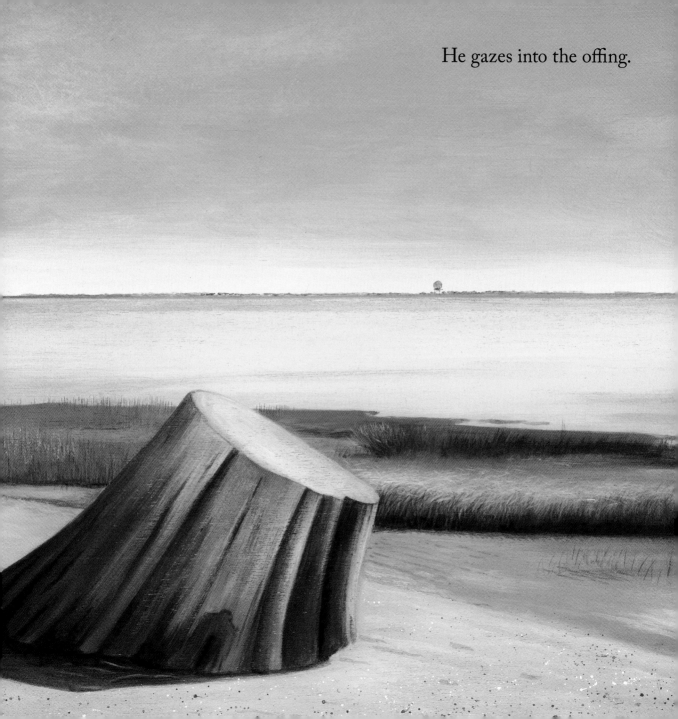

He gazes into the offing.

An enigma lifts his spirits.

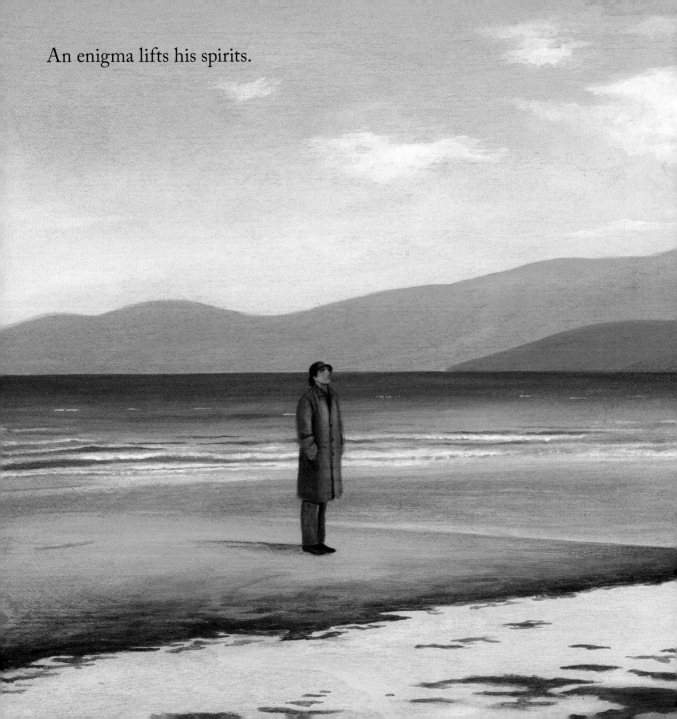

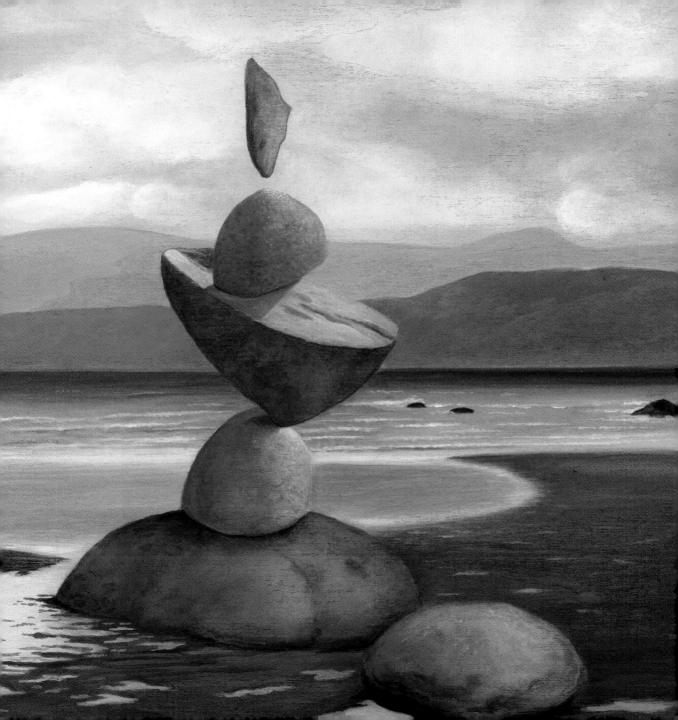

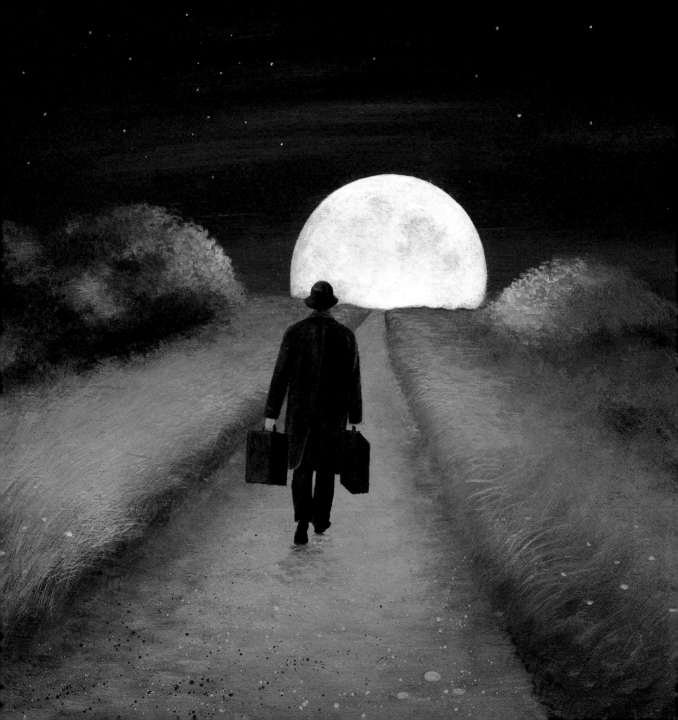

The magnolious moon beckons him onward.

He sets his cares aside during a playful interlude.

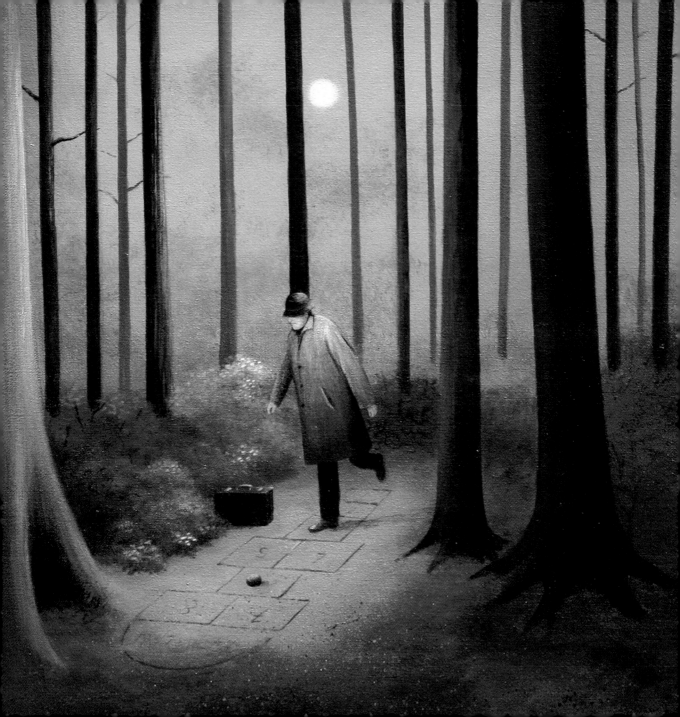

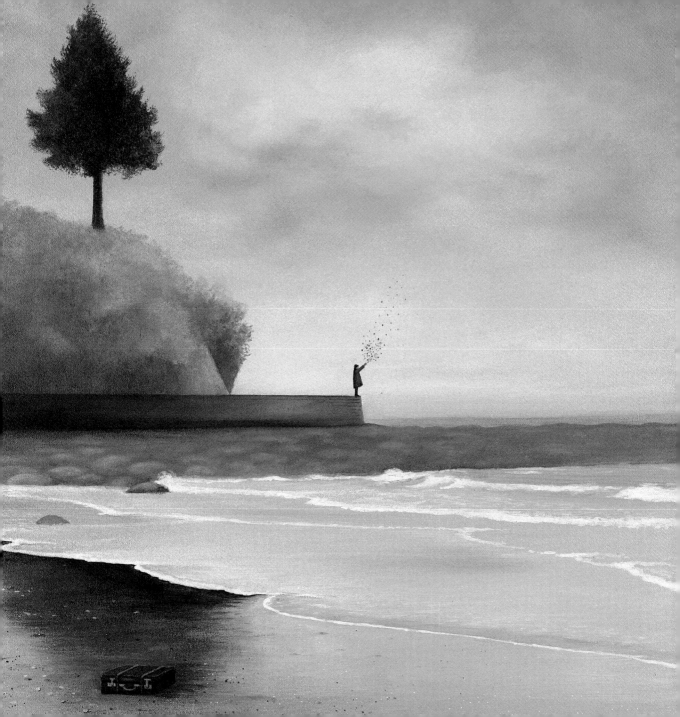

Disburdened of a possession, he finds release.

He soars, serenaded by the susurration of wings.

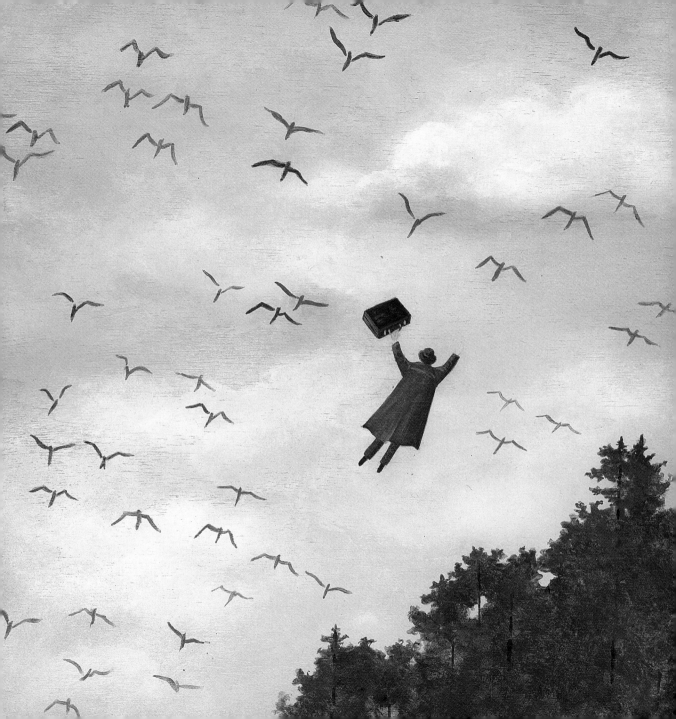

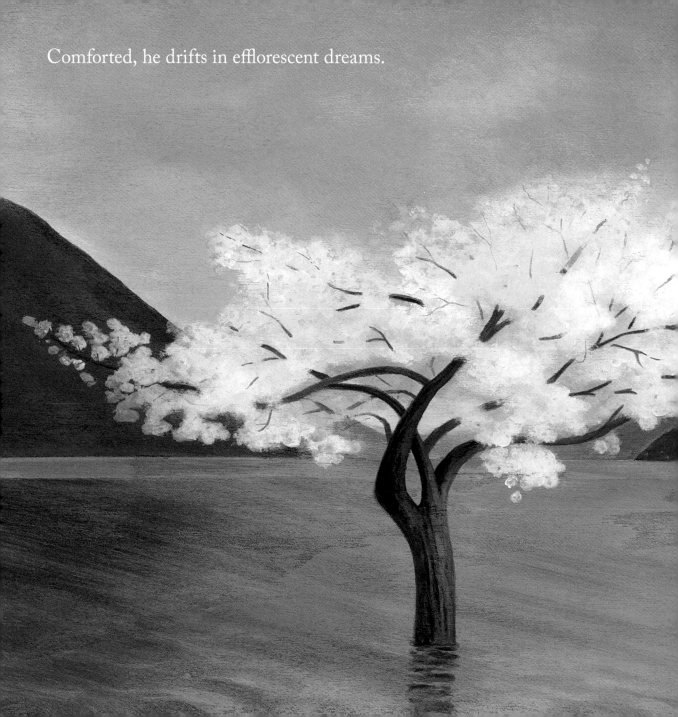

Comforted, he drifts in efflorescent dreams.

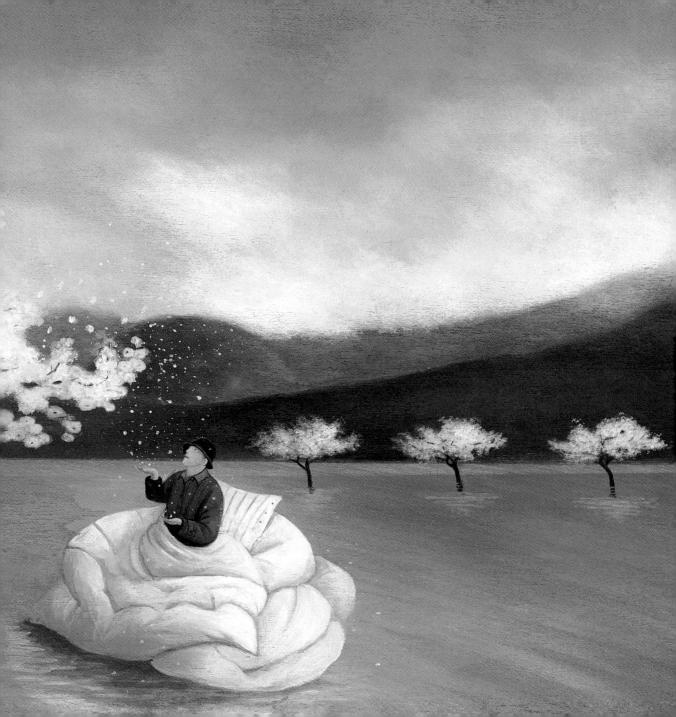

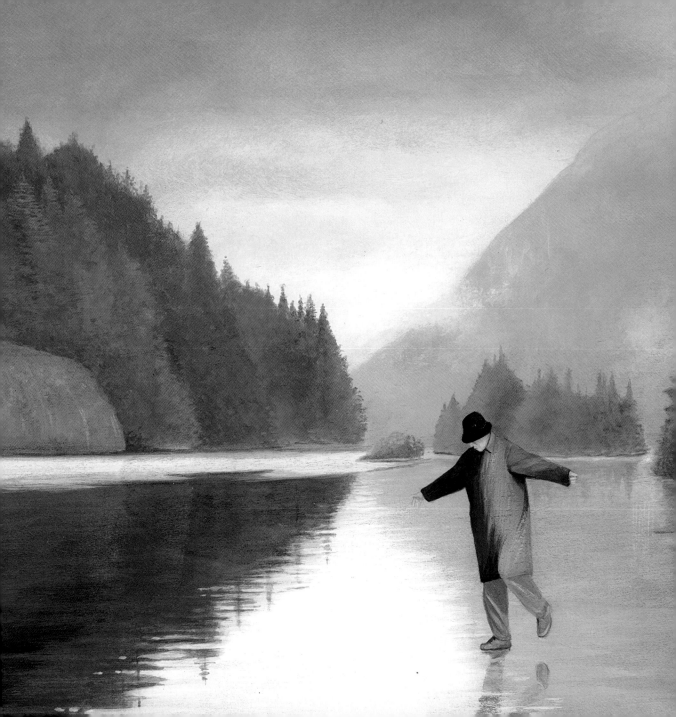

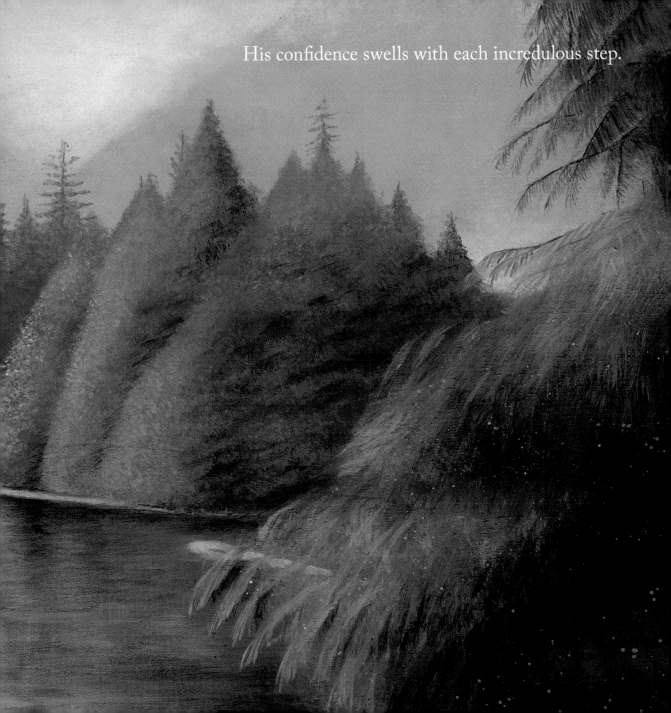

His confidence swells with each incredulous step.

An erumpent new self takes root.

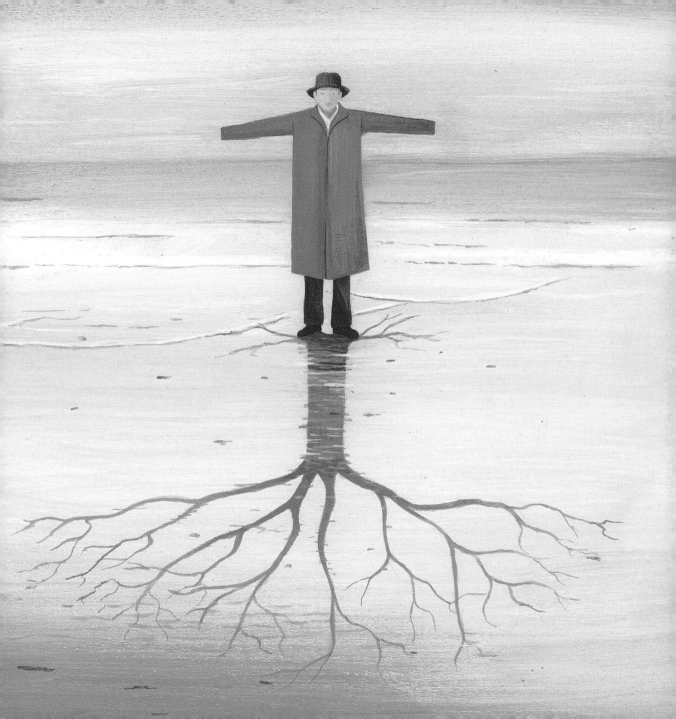

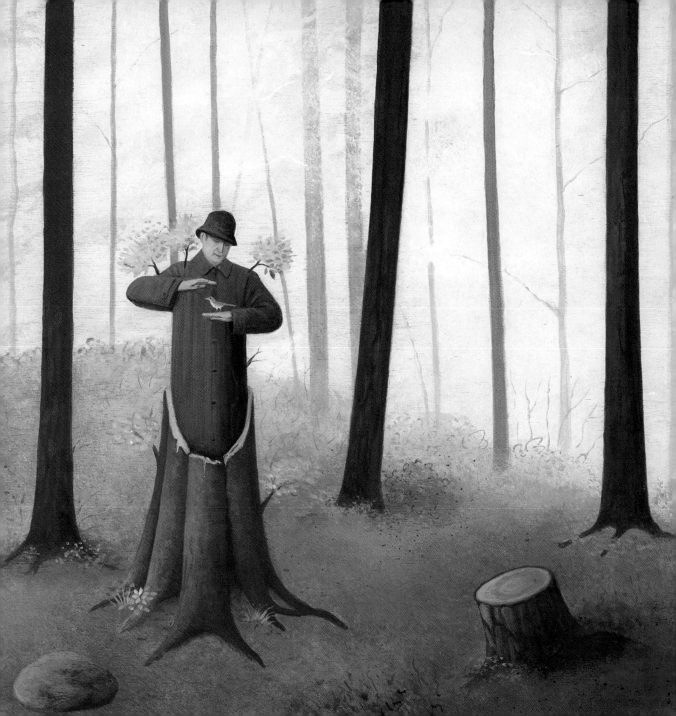

With fledgling felicity, he befriends and protects.

He reflects on his renascence, surrounded by tranquility.

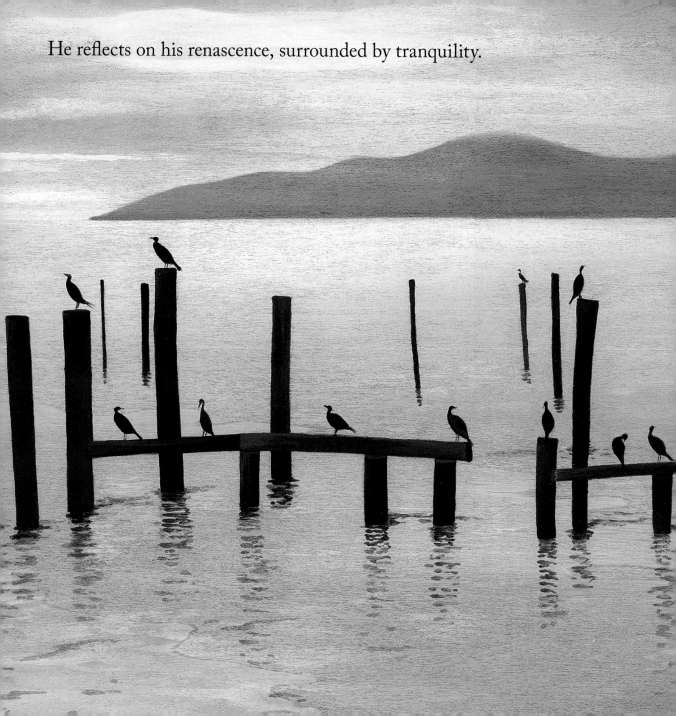

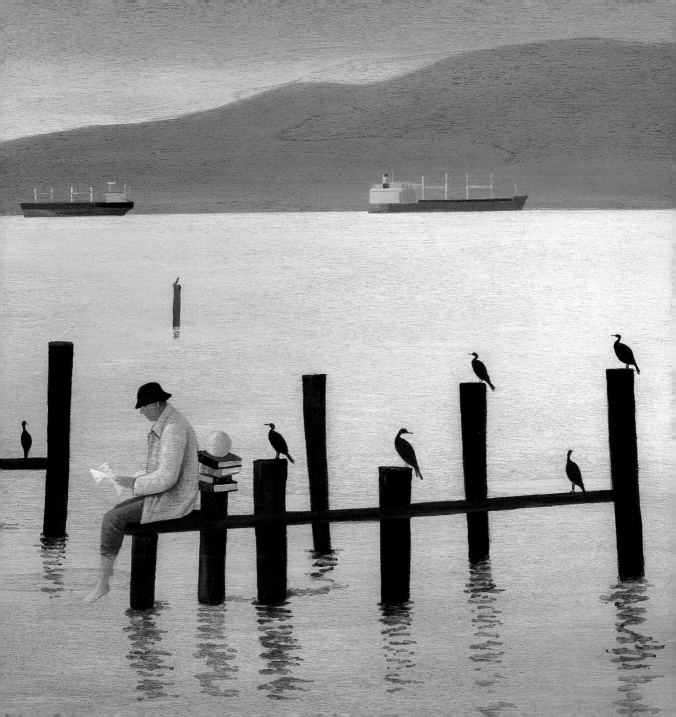

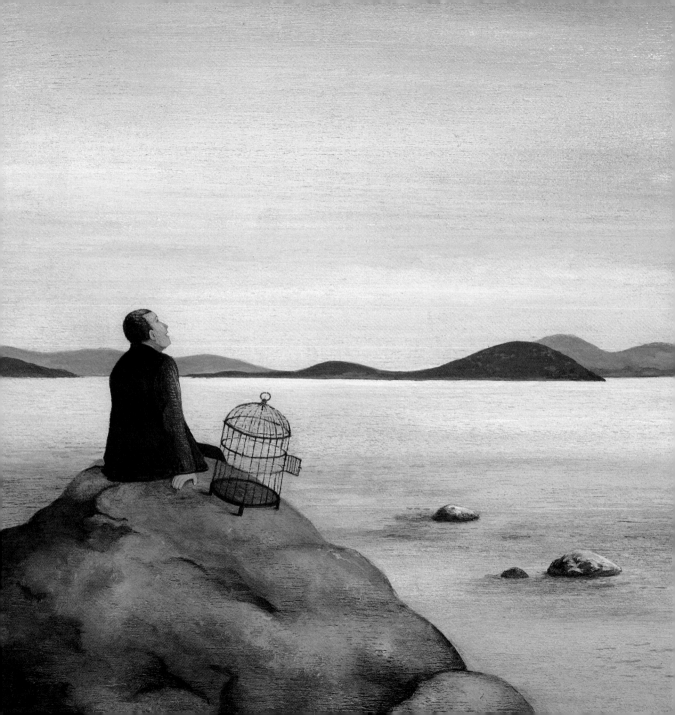

Liberated, Mr. M greets the dawn.

A Quiet Contemplation: Mr. M and the Work of Soizick Meister

Pennylane J. Shen, CURATOR OF JACANA GALLERY

Beginning as humble and intimate 10 x 10 woodblock works, Meister's first series featured Mr. M in unexplainable, often metaphysical situations. In one frame, the enigmatic character finds himself wandering into the heavens or rooted to the earth; while in another, he sets sail in a paper boat.

With such inscrutable imagery, it is no wonder Meister's work has often been likened to the Surrealist masters of the early 20th century. Having been born and raised in Brittany, France, and having resided in various parts of Europe, may account for the Meister's distinctive Western fine art style. The deliberate lack of perspectival space, not to mention the character of Mr. M, reminds one of the work of René Magritte.

Meister's move to Vancouver, BC in 2000, came as an important change to her life and her work. Along with Meister, Mr. M too, travelled, changed and settled to adapt to the West Coast surroundings.

One cannot help but identify the tall coniferous trees that often foreground each piece with Vancouver's natural geography in her second body of work in the Mr. M succession. Although the Canadian landscape has definitely made its presence clear in Meister's work, she is not limited by it. The paintings still retain the ambiguity of their Surrealist influences. Moreover, Meister is hesitant to explain the meaning behind the work, insisting that each viewer's interpretation is as valid as her own. What is clear however is that subtlety remain the upmost important factor in order that each image's narrative be as personal and as specific to the viewer as it is to Meister herself. Having spoken to Meister on a number of occasions, I speculate that the work is of much greater significance than I could have ever imagined, representing a journey that is personal to Meister's story but also universal to the psychological journey of anyone who is searching for something greater than themselves.

The journey of Mr. M echoes the burden of time, the heaviness of memory and the inevitable need to move onward. The work prompts the viewer to question Mr. M's motives. What is he waiting for? Who or what is he trying to find? Where is his final destination?

At the end, we see him resting his feet in shallow waters, reading a book in the company of birds and contemplating the vastness of the sea. It seems our Mr. M has finally cast

anchor. The questions that once swirled around Mr. M's journey's purpose fall into quiet comprehension with this book. The answer is clear. It is sights such as these that remind us of the need to reconcile the past, the importance of contemplating the current and the will to persist onwards despite the unknown.

Whether or not Mr. M has settled for good, one cannot know for certain. For the dream-like quality Meister has given Mr. M demands anonymity, ambiguity and mystery. How else could one capture a figure that embodies everyone and no one?

Review of Soizick Meister's exhibition,
"Rocks and Sky," at Jacana Gallery,
Vancouver, BC, Canada

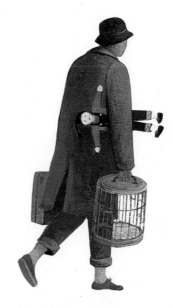

This book was created from a selection of
Meister's Mr. M paintings that seemed to tell a
story of their own. Having lived on the
West Coast all my life, I was especially drawn
to Mr. M's contemplation of and connection to
this landscape. To further link the paintings,
I wrote this text incorporating idioms based on
the artwork as well as arcane words.
Like Mr. M, such word usage is imbued
with mystery. The intention is to encourage
alternative readings of Mr. M's journey and
introduce the intrepid dreamer to an audience
beyond the art gallery, allowing readers to
imagine his journeys and adventures, his
struggles and searches, for themselves. – K.G.

First published in 2010 by Read Leaf
an imprint of Simply Read Books

Text Copyright © 2010 K. George
Art Copyright © 2010 Soizick Mesiter
Review Copyright © 2010 Pennylane J. Shen

CIP data available from Library and Archives Canada

ISBN 978-1-897476-68-0

We gratefully acknowledge for their financial support of our publishing
program the Canada Council for the Arts, the BC Arts Council, and
the Government of Canada through the Book Publishing Industry
Development Program (BPIDP).

Book design by Pablo Mandel / CircularStudio.com
Many thanks to Tiffany Stone and P. George for all their help. – K.G.

10 9 8 7 6 5 4 3 2 1

Printed in China on 100% recycled paper

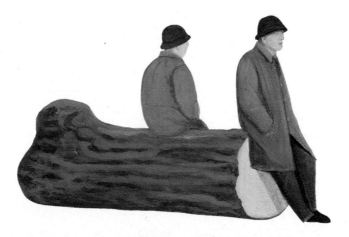

Artist's note: the paintings in this book were done on wood or canvas with acrylics.